"Now we know:

McLuhan

was right."

The Reporter, June 1976

EVERYMAN's McLUHAN

by W. Terrence Gordon
Eri Hamaji & Jacob Albert

MARK BATTY PUBLISHER
New York City

This book is intended as a primer and a guide for readers wanting to explore the writings of Marshall McLuhan. Called media guru when he came to public view in the 1960s, media analyst at the time of his death in 1980, media ecologist with the wave of renewed interest in his work since the 1990s, McLuhan coined the phrase **global village**. If *Bartlett's Famous Quotations* is a reliable indicator, he is probably best known for saying **medium is the message**.

Cy Jameson's title above is a deliberate echo of Tom Wolfe's essay "What if he is right?" published when McLuhan was the subject of critical hype and professional abjuration in equal measure. Those were the heady days of the Beatles, Haight-Ashbury, and Woodstock. If the hype and the abjuration have long since vanished, there is still much radical misreading. These pages are written in the hope of steering readers around the reefs of McLuhan's rhetoric and giving safe passage to the deep and open waters of his ideas. It makes for an exciting voyage of discovery.

MEDIUM IS

THE MESSAGE

How can the medium be the message?

How can the television set's circuits, screen, etc. *be* the ad coaxing us to buy?

McLuhan never intended his phrase to have such a literal meaning. He rephrased the *medium is the message* in different ways at different times for different audiences. These paraphrases are not generally well known.

Here are some that help us get a grip on his idea.

The medium is the message, but the user of the medium is the content of the medium, in the sense that any medium is an extension of the human body.

This expansion on the original saying relates message to content through the term medium, defined in the special sense of any extension of the human body. As we shall see later, the broad sense of medium, unlike its restricted sense in mass media communication, allows McLuhan to range over everything from cell phones (extensions of our ears) to safety pins (extensions of our fingers) and declare that they are all media. It's a move that got him into trouble with thinkers of many stripes, but the reason for his bold step becomes clear from his next paraphrase:

The medium is an environment

McLuhan was, for years, director of the University of Toronto's Center for Culture and Technology. The name speaks volumes about the whole framework of McLuhan's thought and its implicit thesis. It is also a direct link to our current paraphrase of the medium is the message: culture and technology are inseparable because the effect of any new technology is so far-reaching as to reshape the culture that embraces it. Alarmed environmentalists predicted that if the number of horses in New York kept

that produces effects.

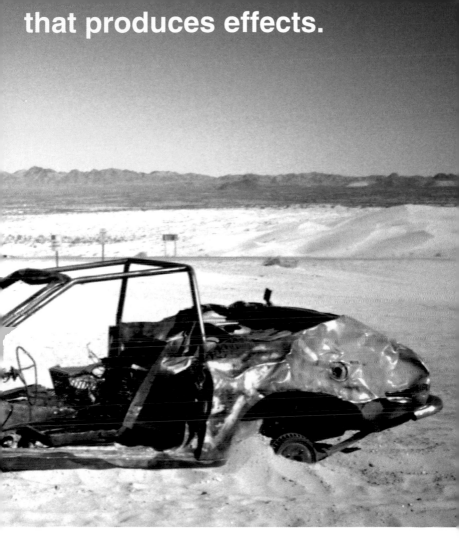

increasing as it did in the closing decades of the nineteenth century, the city would be under ten feet of manure by 1920. The same environmentalists may have welcomed the advent of the horseless carriage as a technological boon for avoiding the catastrophe. But e.e. cummings had not yet warned that **progress is a comfortable disease**, greenhouse effect was not in the lexicon, and the environmentalists had no basis for understanding how the horseless carriage could become a trojan horse.

The medium of language is its own message.

McLuhan believed that any language carries much more power in itself than any particular message that can be expressed through the language. He saw languages as corporate masks or the collective energy of their speakers.

He also saw language as a model for all media, calling it mankind's first technology for letting go of the environment in order to grasp it in new ways.

(Think of a infant letting go of its mother's breast and saying "ma.")

The Medium is the Massage.

This lesser known version of the medium is the message became the title of one of McLuhan's books, first published in 1967. By then, he had realized that his original saying was on its way to becoming a cliché and welcomed the opportunity to recycle it and revitalize it. With the new version he was not simply indulging his insatiable appetite for puns or turning self-mockery into self-rescue. The book carried the subtitle "An Inventory of Effects," emphasizing the principle stressed in the original saying.

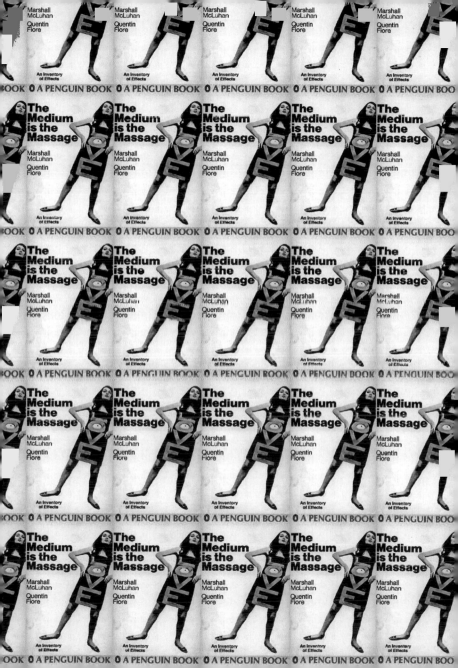

Each technology creates a new environment;

the old environment becomes the content of the new environment.

The key words **content** and **environment** come together here to express the idea of the medium as message through a spatial metaphor. The same metaphor grounds many of McLuhan's observations about the structure of media and the effects they produce. For example, he declared that the launch of Sputnik scrapped nature, in the sense of opening the era in which high-flying hardware circles our planet. In an alternative metaphorical expression of media as environments, he extended James Joyce's pun "utterings-outerings" to include the outer rings formed by the annual growth of tree trunks.

The question does not compel a serious answer, but McLuhan gave one all the same, declaring that effects precede causes because they are inseparably linked as a process. Aristotelian efficient causality he dubbed the offspring of Gutenberg's printing press. And he accused print technology of obscuring the offspring's cousin (the child of an older generation of media) – formal causality. Aristotle himself is marginalized in this family saga (along with his notions of material and final cause), because McLuhan, unlike Aristotle, is not interested in classifying forms but in identifying their effect on the individual and on society.

Formal causes inherent in media operate on our physical senses, the senses that they extend.

The effects of media, like their message, come from their form and *not* through their content.

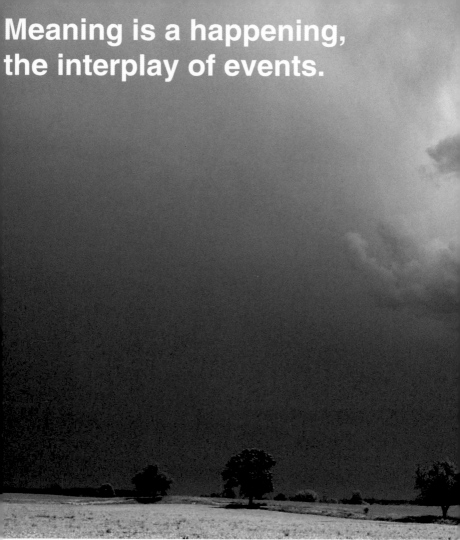

Meaning is a happening, the interplay of events.

Continuing to carefully qualify **message** and consistently distinguishing it from **content**, McLuhan allowed himself on occasion to speak of **meaning**. It was in the nature of a rare historical footnote to his own work, to his thought, and to an important shaping influence. As a graduate student at Cambridge University in the 1930s, McLuhan absorbed the teachings of I.A. Richards, including ideas from the book that Richards co-authored with C.K. Ogden: *The Meaning of Meaning*. McLuhan acknowledged the

extent of his debt to Richards and the deliberate echo of the Ogden & Richards title in the medium is the message. Much of McLuhan's work can be seen as an expansion and application to all media of an idea that Ogden & Richards had first applied only to verbal language. On the first page of McLuhan's *Take Today* (with Barrington Nevitt), we read: "The meaning of meaning is relationship," the interplay of events that turns every medium into a message.

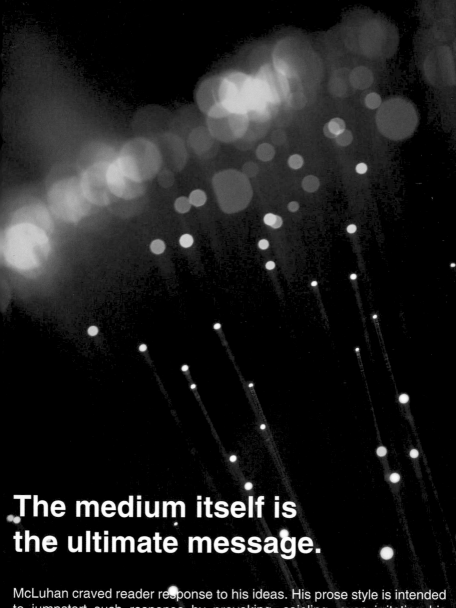

The medium itself is the ultimate message.

McLuhan craved reader response to his ideas. His prose style is intended to jumpstart such response by provoking, cajoling, even irritating his audience. Here the simple qualifier of his original saying invites us to refashion it in our own way.

What's the use of repeating

the medium is the message
the medium is the message
the medium is the message
the medium is the message
the medium is the message
the medium is the message
the medium is the message
the medium is the message
the medium is the message
the medium is the

like a mantra,

if you can't try the idea out for yourself

and make your own application of it?

... for example?

**What difference does it make
HOW you take the message in?**

**Plenty, according to McLuhan.
In fact, it changes EVERYTHING.**

That is the central idea in all of his writings.

Medium is the message is a metaphor for

mEtaMorPhOsiS:

> POINT OF VIEW

For McLuhan, questions were more important than answers. If asked "What's your point of view?" he would prefer to respond with another question: "What's in a viewpoint?" The second question moves toward an answer to the first in the only way that satisfies McLuhan: tentatively, by exploring language, by finding clues to the operation of media through language – itself a medium, if not the medium *par excellence*. The very word viewpoint reveals the privileged place that all things visual hold in western civilization.

The superior power of the eye over the human body's other sensory organs, together with the invention of the alphabet, later intensified by the technology of print, account for this dominance. But while viewpoint makes the visual explicit, it also carries connotations of the static, the restricted, the fixed. Because McLuhan regards such elements as shackles for the questioning mind, impediments to the fullest possible understanding of the world and its ways, he declares throughout his writings that

he does not have a point of view.

> EARLY McLUHAN

At 19, he was an undergraduate student at the University of Manitoba, Canada. It was the 1930s, and the world of advertising caught his attention for the first time. He ventured the opinion that fifty years later the ads of that day would prove to be interesting cultural artefacts. Over those fifty years, McLuhan analyzed advertising repeatedly – first in *The Mechanical Bride*, then in journal articles, a major chapter of *Understanding Media*, and finally in *Culture is our Business*.

BUT FIRST...

> McLUHAN BREAKS INTO PRINT

McLuhan's first published article, "G.K. Chesterton: a Practical Mystic," appeared in *The Dalhousie Review* in 1936. Identifying Chesterton with the true mystics who reveal mysteries rather than obscuring them, McLuhan anticipates the basis of his own eventual program for training in media awareness.

Like Chesterton, McLuhan drew on "the daily miracles" of perception flowing through our physical senses and feeding our consciousness. From this source, he developed the same "extraordinarily strong sense of fact" that he recognized and appreciated in Chesterton's work.

In his teachings, McLuhan was to emulate Chesterton, who relished conflicting appearances that allowed him to call attention to the higher-order truths transcending them.

As for the linchpin of McLuhan's thought, the transforming power of media, it too is to be found in Chesterton, linked to the notion of language as mankind's first technology.

> FROM MADISON, WISCONSIN, TO MADISON AVENUE:
The Mechanical Bride

A whimsical McLuhan once declared Madison Avenue to be the Archimedes of our time and scripted the ancient scientist's time travel to the electronic age with the punchline, "Well, I'll be fulcrummed." McLuhan felt more than a little fulcrummed himself, when he took up his first teaching position as a professor of English at the University of Wisconsin, in the same year that he published his article on Chesterton. He sensed an unsettling gap between himself and his students, though they were not much younger than himself. He suspected that some sort of **cultural undertow** was at work and began to record his reflections on the matter.

Comic strips engage McLuhan's attention in the book, less as examples of what he later calls a **cool medium** than as a mirror of popular culture. Comics also fit McLuhan's educational program, because their dramatic pictorial form provides clues to the powerful tide of visual-auditory bias of magazines, radio and television that began to wash over the twentieth century and displace literary culture. McLuhan alternately condemns and praises the world of comics, but his purpose is always to create awareness of their bias and the values they perpetuate. He reads Little Orphan Annie as the American success story with a psychological twist: the drive to succeed by both pleasing parents and outdoing them. Annie is an orphan by choice. Her isolation and helplessness are potentially frightening, but offset by her innocence and goodness – to say nothing of the campaign she wages so successfully against incompetence, interference, stupidity and evil.

In the hybrid of a science fiction and drama portrayed in the adventures of Superman, McLuhan detects the dominant theme of the

psychological defeat

of

technological man.

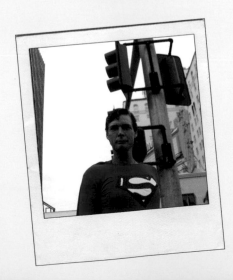

Superman achieves victory through sheer force but remains the alter ego of the ineffectual and downtrodden Clark Kent. In this respect, Superman is nothing more than the wish fulfillment of a man whose personality reveals the true significance of the strip for McLuhan: society's reaction to pressures created by technological advances, the rejection of due process of law, and recourse to violence. Tarzan too has an alter ego in Lord Greystoke. But unlike the maligned Clark Kent, Greystoke is a vestige of feudal times. The contrast between the noble savage and the civilized man does not apply to him; an aristocrat, he renounced the trappings of society in favor of life in the jungle. In McLuhan's interpretation, Greystoke combines the ideals of the YMCA, Rudyard Kipling, and the Boy Scouts.

McLuhan is thoroughly irritated by *Blondie* in the *Mechanical Bride*, because the strip is pure formula and cliché. Dagwood, a frustrated victim trapped in suburban life, gets little respect from his children, and none from McLuhan. Readers might find Dagwood's snacking comical, but McLuhan finds it comtemptible – a symbol of the abuse that Dagwood endures and the insecurity it engenders. This psychological take on Dagwood is rounded out in terms that revert to the *Mechanical Bride's* emphasis on society's values. McLuhan explains that, unlike the character of Jiggs ("Bringing Up Father"), who belongs to the first generation to realize the American dream, Dagwood is second generation and lacking the competitiveness that assured his father's success. McLuhan's speculation that the *Blondie* strip would survive into an age alien to it, has been borne out in the first decade of the twenty-first century.

Dagwood's world of repetitive and inescapable dilemma is offset by the delightful predicaments in the Dogpatch of Al Capp's *Li'l Abner*. Satirical, ironic, free of the shallow sentimentality that repelled McLuhan, Capp's strip works toward the same purpose as McLuhan himself – the development of sharpened perceptions. Just as McLuhan approaches his objective by the use of what he called the mosaic technique (multiple points of view), Capp makes the Li'l Abner character a mosaic of hero images. For McLuhan, the real hero is Capp, seeking endlessly to expose the delusions and illusions foisted on society by politicians, business, and the

society

prefers

somnambulism

to

awareness.

But perhaps most remarkable is the suggestion on his opening page that the proliferating forms of American advertising could be a healthy thing for the nation's social and political life.

The undercurrent of moral indignation that marks *The Mechanical Bride* is absent in earlier publications, where McLuhan simply catalogs symbols and wit in rich proliferation, behavior patterns in revealing evidence of social transformation. He regards all this as containing an opportunity for an educational program directed toward self-knowledge and self-criticism. It is an outlook that puts him closer to the McLuhan of the 1960s and 1970s than to the father of *The Bride*, makes him unequivocally optimistic in his outlook, as he concludes that

America can still fulfill its Utopian promises,

because its Jeffersonian tradition and

its psychological vigor

have remained

intact.

By the time *The Mechanical Bride* reached publication form, its treatment of advertising was marked throughout by a sarcastic tone that is in stark contrast to what McLuhan readers had discovered in his early essays.

McLuhan moves from his description of the sweet, nonsexual, innocent, clean, and fun-loving gal of a vintage Coca-Cola poster to commentary on a quotation from a Coke executive discussing the company's marketing strategy and concludes that there

"would seem to be a very small gamble, with the globe itself becoming

a coke sucker."

Though the Duchamp painting that inspired the title of *The Mechanical Bride* is not shown in the book, nor even alluded to, it is referenced repeatedly in the reproductions of ads for nylons, beauty preparations, Bayer Aspirin (featuring a drum majorette), and more, including a Four-in-One Proportioned Girdle that anchors McLuhan's comments-headed Love-Goddess Assembly Line. As in each section of the book, he opens with questions intended to move the reader toward a conclusion about the message of the ad in question:

Did you notice the Model-T bodies of the women in that revived 1930 movie last night?

Can the feminine body keep pace with the demands of the textile industry?

His own conclusions, to the end of his career, emerged from what such questions might reveal about the interplay of medium and message:

Nickelodeon platter all same as Digest yatter?

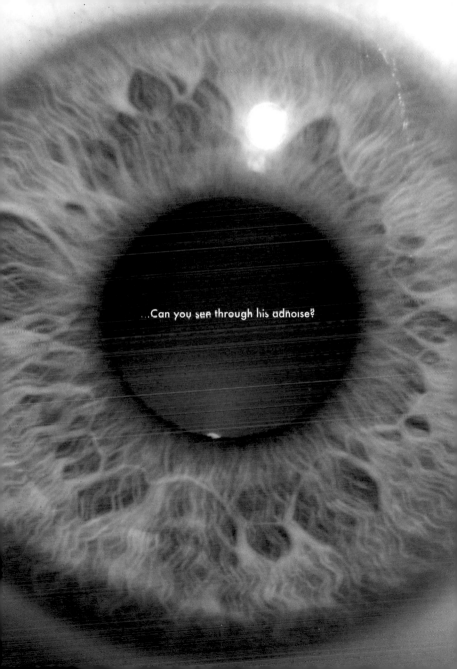

YOU'VE HEARD
MONEY TALKING;

DID YOU UNDERSTAND
THE MESSAGE?

McLuhan is relentless in his attacks, constantly ferreting out the absurdities of the ads he analyzes. *Reader's Digest*, the National Association of Manufacturers, the educational establishment, Quaker State Motor Oil, haberdashers, and candy companies all take their licks. Nobody is safe: John Wayne and Humphrey Bogart are roasted on the same fire as Henry Booth Luce and Mortimer Adler. McLuhan refers to his subtitle for *The Mechanical Bride*: The Folkore of Industrial Man in the closing pages of the book, inviting readers to find their own answer to the question:

Are ads themselves the main form of industrial culture?

But for all its vigor, *The Mechanical Bride* had lost some of its grit in the transition from the draft version of "Guide to Chaos." Much of the earlier manuscript was cut altogether. Though key-phrases such as know-how and man of distinction were retained as titles for exhibits in the book, various punchy passages vanished. Their disappearance deprives readers of helpful insights into McLuhan's reason for choosing the analogical and integrating techniques of classical learning over the logical and isolating techniques of modern science. And a suppressed reference to technological man's illusion of being at home everywhere and with everybody anticipates much more than McLuhan's later pronouncements on the global village and the retribalization of Western culture.

The passage repays attention. The comment on the requisite of scientific experimentation encapsulates McLuhan's reason for choosing the analogical and integrating techniques of classical learning over the logical and isolating techniques of modern science. As for the reference to technological man's illusion of being at home everywhere and with everybody, it anticipates much more than McLuhan's later pronouncements on the **global village** and the **retribalization of Western culture.**

Twenty years after the original publication of *The Mechanical Bride*, McLuhan would grow even more concerned and speak more forcefully of electronic technology turning that illusion into the reality of discarnate mankind,

at

home

nowhere

and

sustained by

no illusion.

If the sustained sarcasm of *The Mechanical Bride* is at odds with earlier and later McLuhan, the book's objectives are not.

The origins of words were often instructive clues for McLuhan to their full meaning and application.

Sarcasm is NO exception.

sarcasm

[sahr - kaz - uhm]

Derived from the Greek, meaning to rip off the flesh, the term has obviously lost its original force, but its root word is an apt metaphor for McLuhan's practice of tearing off the hide to reveal the hidden,

the

medium

under

the

message.

> FROM PRINTING AND SOCIAL CHANGE
TO CULTURE WITHOUT LITERACY

In an essay entitled "Printing and Social Change,"[2] McLuhan focused principally on the effects of printing but also anticipated broader themes from the major books he would soon publish: *Gutenberg Galaxy* (1962) and *Understanding Media* (1964).

Characterizing the printed word as the arrest of mental activity allowed him to bring together his basic but widely applied notion of a medium as an extension with that of the "pure process" of thought. In *Understanding Media* he would go on to identify the unique characteristic of the latter as being exempt from the typical action of media operating in pairs.

Already, in 1959, McLuhan was emerging clearly as both analyst and historian of media, scrutinizing printing as the focal point of a group of technological skills, each with its own social history that demanded attention for a full understanding of its impact on the individual and on society as a whole. His frequent and explicit references to the Gutenberg era as a period in which the vitality of new forms spread into all phases of life and consciousness combine with clear indications that he is moving inexorably toward the formulation of his laws of media:

From one point of view the scanning finger of the TV screen is at once the transcending mechanism and a throwback to the world of the scribe.

Any history of technology is filled with such unexpected reversals of form resulting from new advances.

Central to McLuhan's own program, and to the mindset he wishes to engender, in order to launch the educational reform required by the post-Gutenberg era, is a radical commitment to cast off the shackles of visual orientation and embrace the visionary quality of scientific discovery.

Even earlier, McLuhan had crammed many of the themes of *The Gutenberg Galaxy* and *Understanding Media* into essays in serial publications. Such was the case in the inaugural volume of the journal associated with McLuhan's interdisciplinary seminar at the University of Toronto: Explorations One (1953). Read today, his contribution titled "Culture without Literacy" [3] illuminates his insights with complementary formulations of themes by key phrases less emphasized or entirely absent from his later writings:

posthistoric man,
the grammar of gesture,
the coherence of the world in latency,
the radical imperfection in mechanical media,
the inner dialogue or dialectic of print culture.

There are fresh analogies: diversity and equilibrium of social awareness assimilated to the body-mind network; fresh metaphors integrating media: "the macadamized surfaces of the printed page," and important precisions: the homogeneity of oral culture is radically different from the homogeneity of print culture. Explicit commentary on language as a medium, a notion unifying McLuhan's thought from *Understanding Media* to his posthumously published *Laws of Media*, is to be found here already.

McLuhan's orientation to the Symbolist perspective is subtly evoked when he speaks of divided and sub-divided sensibility resulting from

failure to recognize the multiple languages
with which the world speaks to us.

This is linked to the theme of invisibility of environments, a notion in turn linked to the unity among all media.

"[B]ut in respect of this anonymity [of those originating the messages or forms] it is necessary to regard not only words and metaphors as mass media but buildings and cities as well."

In the age of earth-orbiting satellites,
McLuhan would often repeat that they scrapped nature.

Here, four years before Sputnik opened that era, he takes stock
of the fact that with modern technology the entire material of our
planet and the thoughts and feelings of humanity have become
the matter of art, and that, in this sense,

there is no more nature.

> AFTER THE MECHANICAL BRIDE BEFORE UNDERSTANDING MEDIA

A full decade before he published *Understanding Media*, McLuhan offered the readers of *Explorations Two* (1954) an embryonic version of the book, and many of its key insights, in an essay entitled "Notes on the Media as Art Forms."[4] Between this essay and *Understanding Media*, he would say for the first time that the medium is the message; here the same principle is articulated at the end of his opening paragraph as a corollary to his observation on the widespread inattention to communication as involvement in a shared siutation: "[I]t leads to ignoring the form of communication as the basic art situation which is more significant than the information or idea 'transmitted.'" And so the theme announced in the title, the link between medium as message and art forms, is established and opens the way to the manifold illustrations of the link in the text that follows. Even before this valuable paraphrase and expansion of basic McLuhan are introduced, his opening sentence ("The use of the term 'mass media' has been unfortunate.") is an explicit caution against the excessively narrow view of media to which commentators would fall prey in discussing *Understanding Media*.

As always, careful and reflective reading is repaid by insights to be gleaned from McLuhan's reworking of his themes: "Every medium is in some sense a universal, pressing toward maximal realization. But its expressive pressures disturb existing balances and patterns in other media of culture." Among the condensed riches of this brief essay, it is possible to detect a preliminary formulation of a notion that would ultimately appear as the **principle of reversal** in McLuhan's posthumously published *Laws of Media*: "The intensely abstract character of the printed page was to be the matrix of the technology of America. But paradoxically, the new technology was to produce a new set of arts and a new architecture which was anything but abstract."

> THE MEDIA FIT THE BATTLE OF JERICHO

Under this title, in a piece printed originally in *Explorations 6* (1956),[5] McLuhan first used the thrusting and questing style of writing that he referred to as his probes. Like Joshua's trumpet, a McLuhan probe is a clarion call; like Wyndham Lewis's *One-Way Song*, cited in the opening lines, it sabotages the conventions of prose, offering "paragraphs" as short as half a line; like all media, whose operation McLuhan explores with its help, the probe is a technology or extension. As such, it occupies a privileged place, for its function is to extend consciousness, the essential function of all language and the key to understanding media.

As McLuhan sounds one blast after another through the medium of his probes, he offers us that key by evoking the rudimentary semiotics of animal languages, the incantatory power of language before writing, the effect of writing on the dynamics of the spoken word. His probes suggest as much as they show and show what they suggest, inviting us to move with the author to the bold conclusion that all languages are mass media and that the new media are new languages.

> THE MECHANICAL BRIDE'S ELECTRICAL BROOD

McLuhan spoke not only of the global village but of the globally dilated senses of mankind in the electronic age. Late in his career, more concerned than ever about what was at stake, he summarized the effect of electric technology as a giant ripping off of the flesh. This notion is present as a muted theme in McLuhan's master work, *Understanding Media.*

> UNDERSTANDING MEDIA

No sooner had the original edition of *Understanding Media* appeared in 1964 when the author was on his way to fresh insights about how media create new human environments. As he surged ahead, refining his own thinking, the first generation of readers of *Understanding Media* began to discover what he had already thought out. More than forty years later, the book still offers a challenging invitation to begin a voyage of intellectual discovery. The book's relentless blizzard of ideas illustrates one of its own key points: faced with information overload, the mind must resort to pattern recognition to achieve understanding.

From the vortex of *Understanding Media* **ten ideas** surface to unify the work.

1)

We instinctively think of media as those that bring us the news: press, radio, and television. McLuhan thought of a medium as an extension of our bodies or minds: clothing is an extension of skin, housing is an extension of the body's heat mechanism.

The stirrup, the bicycle, and the car extend the human foot.

The computer extends our central nervous system.

**A medium
or
a technology
can be
any extension
of
the human being.**

The
extension
of

the
foot

2) Media operates in pairs, one effectively "containing" another.

The pairs can operate in tandem; so, telegraph contains the printed word, which contains writing, which contains speech. In this way, the contained medium is the message of the containing one. This typical interaction of media is not generally noticed by users, but its effects are extremely powerful, according to McLuhan, so much so that any message, in the ordinary sense of "content" or "information," is dwarfed by the medium itself.

In this sense, "the medium is the message."

3) There are exceptions to media working in pairs.

McLuhan finds two.

In the example given above, speech is the content of writing,
but one may ask what the content of speech is.
His answer is that speech contains thought.

Here the chain of media ends.

Thought

is a

nonverbal

and

pure

process.

Media are powerful agents of change in

4) how we experience the world,

how we interact with each other,

how we use our physical senses –

the same senses that media extend.

They must be studied for their effects, because their interaction obscures those effects and deprives us of the

control

required

to

use

media

effectively.

5) McLuhan teaches that new media do not so much replace each other as complicate each other.

The technology of mankind in the **age of acoustic space** – the technology from which writing, print, and telegraph later developed –

was speech.

Transformed into writing, speech lost the quality that made it part of the culture of acoustic space.

It acquired a powerful visual bias, producing carryover effects in social and cultural organization that endure to the present.

6) McLuhan's classification of media hinges on the contrast between well-defined, sharp, solid, detailed forms of sensory input and those that require the senses to fill in _____ (what is missing).

This is the basis of the contrast between **hot** media

radio

print

photograph

TV

and **cool** media:

 telephone

 speech

 cartoon

 movie

7) In discussing the myth of Narcissus, McLuhan begins by pointing out the common misrepresentation in which Narcissus is said to have fallen in love with himself. In fact, it was his inability to recognize his image that brought him to grief. He succumbed to the same numbing effect that all technologies produce, if the user does not scrutinize their operation.

Technologies create new environments,
the new environments create pain,
and the body's nervous system shuts down
to block the pain.

8) In the case of Narcissus, a new medium both extends and amputates the human body; McLuhan finds another dimension of opposing effects accompanying the transition from mechanical to electronic technologies.

This transition has involved
a relentless acceleration of all human activity,
so extensive that the expansionist pattern
associated with the older technology
now conflicts with the contracting energies
of the new one.

ion,

oulation

lge,

nto

ion

e

nnology

ed

village

dge

ized

ered

ed

ties.

9)

McLuhan's analysis identifies the effects of media in all areas of society and culture, but

the
starting
point
is
always
the
individual,

since media are defined as technological extensions of the body.

A

As a result,
McLuhan often puts his questions and conclusions
in terms of the ratio
between our physical senses
(the extent to which we depend on them relative
to each other)
and what happens when that ratio is modified.
Any such modifications
inevitably involve a psychological dimension.

In this respect,
they point to
the inadvisability of

a

rigid

separation

of

the

physical

from

the

psychological,

perhaps in all analysis,
but especially for
an understanding of
McLuhan's
teachings.

10) Western culture, with its phonetic literacy, when transplanted to oral, nonliterate cultures, fragments their tribal organization and produces the prime example of media hybridization and its potent transforming effects.

At the same time, **electricity** has transformed Western culture, dislocating its visual, specialist, fragmented orientation in favor of oral and tribal patterns.

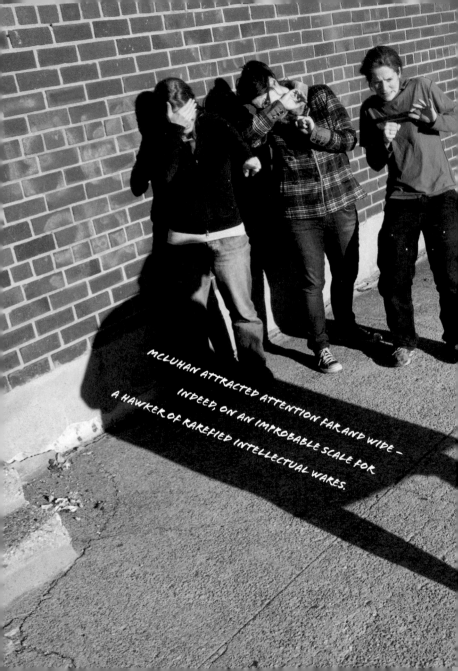

MCLUHAN ATTRACTED ATTENTION FAR AND WIDE – INDEED, ON AN IMPROBABLE SCALE FOR A HAWKER OF RAREFIED INTELLECTUAL WARES.

> FROM PRINTING AND SOCIAL CHANGE
TO CULTURE WITHOUT LITERACY

Characterizing the printed word as the arrest of mental activity allowed McLuhan to bring together his basic but widely applied notion of a medium as

an extension

with that of the

"pure process"

of thought.

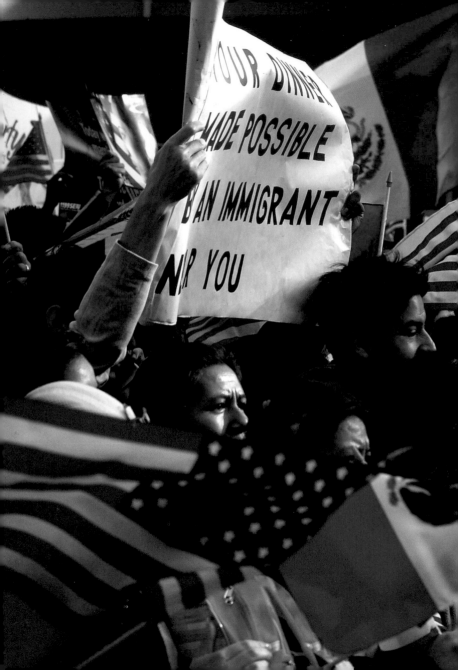

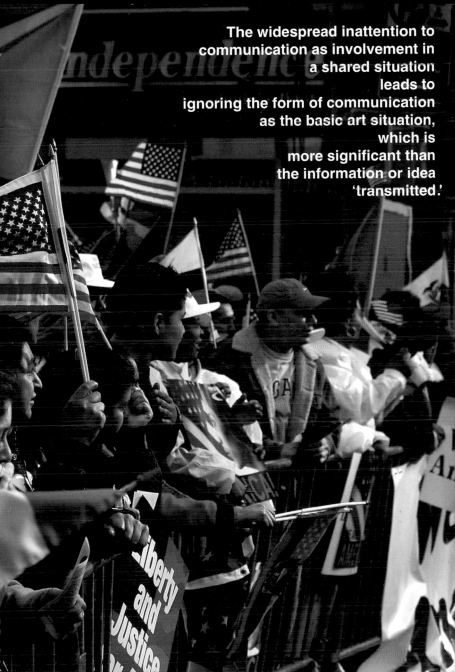

The widespread inattention to communication as involvement in a shared situation leads to ignoring the form of communication as the basic art situation, which is more significant than the information or idea 'transmitted.'

LIKE
JOSHUA'S
TRUMPET,

A MCLUHAN PROBE
IS A CLARION CALL.

THE PROBE

IS A

TECHNOLOGY

OR

EXTENSION.

THE
INVENTION OF
THE ALPHABET

AND THE RESULTING INTENSIFICATION OF

THE VISUAL SENSE IN THE COMMUNICATION PROCESS

GAVE SIGHT

PRIORITY OVER HEARING,

BUT THE EFFECT WAS SO POWERFUL THAT IT WENT

BEYOND COMMUNICATION

THROUGH LANGUAGE

TO RESHAPE

LITERATE SOCIETY'S

CONCEPTION

AND

USE

OF

SPACE.

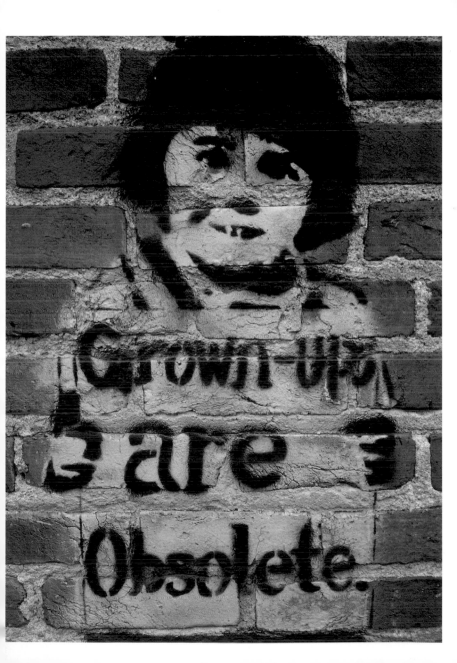

When media combine, both their form and use change.

So do the scale, speed and intensity of the human endeavors affected.
And so do the environments surrounding the media and their users.

The hovercraft is a hybrid of the boat and the airplane.
As such, it eliminates not only the need
for the stabilizing devices of wings and keels,
but the interfacing environments of landing strips and docks.

Grammar is
the art of
interpreting
not only
literary
texts
but
all
phenomena.

Above all,
grammar
entails
a fully
articulated
science of
exegesis,
or
interpretation.

One of the principal
intellectual developments
of the past century or so has been
supplanting of linear perspective
by a multi-locational mode of perception.

Pho

[yellow

iPod shuffle

> CULTURE IS OUR BUSINESS

Compared with *The Mechanical Bride*, *Culture Is Our Business* (1970) reveals much more ambivalence on McLuhan's part toward the advertising studios. If he appears to have more admiration than condemnation for the techniques of the trade, it is because he restrained himself from a stance of askance. When his disapproval becomes explicit, it is of the ends of advertising and not the means, because his own were no different.

"[Making someone ill, then selling the cure is] the way advertising is done. They start off with the effects then look for the causes. That's how I prophesy. I look around at the effects and say, well, the causes will soon be here."

In *Culture Is Our Business*, McLuhan identifies advertising as the cave art of the twentieth century. Neither is intended to be examined in detail but to **create an effect**.

There is a further similarity in that cave art and advertising both express corporate aims rather than private thoughts. McLuhan comments on the social and emotional upheavals brought about by twentieth-century technology but continues to withhold his judgment.

The book does for the advertising of the 1960s what *The Mechanical Bride* did for that of the 1940s. The effect of television made this update necessary. The title is a deliberate put-on of the nineteenth century North American mindset that "business is our culture."

With the advent of radio, movies, and television,

culture became the

biggest business in the world.

Only rarely does McLuhan comment on the hundreds of ads reproduced in the book. His preferred method, as in *The Mechanical Bride*, is to juxtapose ads with his own commentary probing their significance, questions for readers to contemplate, or quotations and observations from a gallery of authors: James Joyce, T.S. Eliot, William Congreve, Alfred North Whitehead, Ashley Montagu, and Karl Polanyi. McLuhan's punchy phrases proliferate: "costume is custom," "the end of the muddle crass," "Jung and easily Freudened," "freedom from the press."

Culture Is Our Business intensifies the mosaic approach that marks all of McLuhan's writing, pushing it to its most playful and thought-provoking extremes. A section headed "Rear-View Mirror" begins by juxtaposing James Joyce's observation that "pastimes are past times" with a travel ad showing a British beefeater under the caption "On a clear day, you can see a long, long time ago." Then the mosaic quickly becomes intellectually abrasive, with an ad for bananas headed "this page is dedicated to the proposition that all bananas are not created equal." In combination with another carrying a quotation from Federalism and the French Canadians, this page becomes a diptych, making the point that the **concept of nationhood has been made obsolete by the retribalization of the West**. And the cliché, banana republic, is tossed back on the compost heap of language. McLuhan also slips in a word about gaps and interfaces – as much a part of his method as of the new environment he evokes.

McLuhan was not pleased with the execution of the book when it appeared. He predicted that it would become a collector's item among the cognoscenti, who would pick up on the myriad errors in the copy. The book had not been sent to him for proofreading and apparently had not been proofread by anyone at the publisher's office either. The dustjacket, planned by McLuhan himself to show a cyclops as an image of the hunter in the age of information, parodied a well-known ad for the Hathaway man and his eye-patch.

> FROM CLICHÉ TO ARCHETYPE

In sharp contrast to the mosaic form of organization that McLuhan favored is the encyclopedia article format of *From Cliché to Archetype*, published in 1970. Ten years in production, the book was a collaborative effort between McLuhan and Canadian poet and playwright Wilfred Watson.

The terms cliché and archetype appear as entries in the work, but they prove to be as inseparable as medium and message. Archetype, like the basic meaning of type, refers to a pattern or model.

In literary analysis, an archetype manifests as a symbol or image, recognizable because it is REPEATEDREPEATEDREPEATED.

But clichés are repeated too, and it is precisely their repetition that turns them into clichés.

This is why McLuhan and Watson stress the connection between the two terms. An archetype is an open category, able to enrich and complexify itself; a cliché is not a category, and its form is fixed. But it can be a point of departure for a modified and parallel form, as it was for McLuhan himself, when he rephrased the medium is the message as the medium is the massage. Such a procedure, privileged in the echoland of Joyce's *Finnegans Wake*, is a literary device with ancient roots. Its long history, pervasiveness within many literary traditions, and rhetorical power explain why McLuhan evoked Joyce in the closing pages of his doctoral dissertation on Thomas Nashe.

Clichés are not limited

Just as McLuhan stretched the sense of medium, he and Watson stretch the sense of cliché, allowing it, at various times, to mean extension, probe, or means of retrieving the past. They call perceptions clichés, because our physical senses form a closed system, and they view all media of communication as clichés, because media extend our physical senses.

The simplest definition of cliché for McLuhan and Watson is that of a probe. Here is a paradox exploited by artists, who sharpen old clichés into new probes – new forms that stimulate new awareness. Between archetypes and clichés there is both contrast and interaction. Being fixed, a cliché is incompatible with another, even when they are related in meaning. Getting down to the nitty-gritty and getting down to brass tacks cannot be combined into getting down to brass nitty-gritty or getting down to nitty-gritty tacks. By contrast, an archetype, being an open set of forms, may grow richer, acquiring new clichés as its constituent members. McLuhan and Watson define the archetype as a retrieved awareness or new consciousness, created by probing an archetype with an old cliché. *From Cliché to Archetype* views all forms – in language, visual arts, music, and other domains – as reversal of archetype into cliché. But cliché also reverses into archetype.

McLuhan and Watson find parallels between verbal and non-verbal types of clichés, citing a strong similarity between phrases such as green as grass and white as snow and the internal combustion engine.

The similarity is linked to both the form of the clichés involved and McLuhan's notion of technology spawning **new environments**, in that neither the phrases nor the engine operate with any control of their form on the part of the user.

to modes of perception.

Both the clichés and the engine create new environments:

1) **meaningless communication and endless commuting respectively;**

2) **invisible/visible junkyards of speech/writing (the vehicles of thought) and visible junkyards of scrapped road vehicles respectively;**

3) **disfigured mindscapes and landscapes respectively.**

McLuhan and Watson take the connection between verbal and nonverbal clichés and their corresponding archetypes further. They note that language extends all our physical senses at once and that these are integrated when language is spoken, but that the visual sense is isolated and highly specialized when language is written. Because McLuhan and Watson conceive of clichés as media/extensions/technologies, they detect not only similarities but direct links between the effects of past technologies and the accretion of clichés that characterizes language.

I'm dog tired.

So, hunting dogs enriched the lexicon of English with phrases

He's such a dog.

such as to turn tail, top dog, to run to earth, to be on the track, etc.

As for parallel interaction of clichés and archetypes in verbal and nonverbal domains, McLuhan and Watson invite readers to consider the example of a flag on a pole. The flag by itself is a cliché, a fixed and unalterable symbol of the country it represents, just as the name of the country is. Citizens do not have the option to modify it at will. By contrast, a flag on a pole is an archetype, because any flag can be hoisted in place of another. In this sense, any cliché can interchange with another within the archetype to which it belongs.

McLuhan and Watson challenge readers to discover the full meaning of the terms cliché and archetype from a unique feature of the book. Its table of contents appears neither at the beginning nor the end but alphabetically under T. Since all the material in the book is arranged under alphabetical headings, the table of contents is useless, except as a pointed reminder that archetypes can reverse into clichés.

Soon after the publication of *From Cliché to Archetype*, its theme led McLuhan to a study of structuralism, in which he would identify the paradigms of European structuralists as sets of archetypes. And his reflections on the interplay of cliché and archetype also led to his exploration and development of the interplay of figure and ground. But his initial decision to write the book may have been motivated by the desire to wrestle the domain of the archetype away from his rival Northrop Frye. Five references to Frye occur in the book, including an extensive quotation from William Wimsatt, who takes Frye to task for failing to consistently use his own distinction between value and criticism in his *Anatomy of Criticism*. When McLuhan turned his attention to the writings of Jean Piaget, he concluded that the concept of the archetype as developed by Frye, i.e., without the complementarity of cliché/archetype, was unnecessary. But the archetype had been useful enough to be incorporated in *The Gutenberg Galaxy*, published eight years before *From Cliché to Archetype.*

Ultimately, McLuhan linked

the symbiosis of cliché and archetype to the symbiosis of medium and message,

noting that

any medium surrounds both its users and earlier media.

This results in

resonance and metamorphosis between media and their users,

a nonstop process which is the heart of the subject matter of *From Cliché to Archetype.*

Within the whole of McLuhan's work, this relatively late book marks the emergence of the key concept of retrieval – the fourth of the media laws he would add to those of extension, obsolescence, and reversal. Retrieval is the only entry in the book under R. It becomes clear from McLuhan's correspondence following the appearance of the book that the concept of retrieval was occupying a central place in his evolving thought and would soon take its place in the interlocking tetrad of media laws that would appear in definitive form in his posthumously published *Laws of Media.*

> LAWS OF MEDIA

When McLuhan's first essay under this title appeared in *et cetera/ ETC.: A Review of General Semantics*,[5] it may have seemed an unlikely forum. But general semantics, in the vision of its founder, Alfred Korzybski (1879-1950), was essentially a form of applied philosophy, organized loosely around the basic objective of training the human animal to recognize pitfalls of language and thereby make more efficient use of the central nervous system. In this respect, there is more than a tenuous link between Korzybski's vision and McLuhan's call for educational reform based on understanding the operation of new media as languages and their effect on the interplay of our physical senses. In fact, as Korzybski continued his work during the 1940s, McLuhan took notice of it and made prominent mention of it in the introduction to his Cambridge University doctoral thesis. There are oblique references to Korzybski in various McLuhan publications and specific references to his concept of **time-binding**.

In *Understanding Media*, McLuhan had already developed three of the four laws of media without naming them as such; here all four are established in relation to each other as the two figures and two grounds of metaphor, and their ratios "extend to the four irreducible relations in [all] technology." What Korzybski might have thought of McLuhan's laws of media, given that their source is traced here to Aristotle, must remain a matter of speculation with substantial prospect for revealing principled opposition between the two thinkers, for Korzybski referred to his general semantics as based on "non-Aristotelian, infinite-valued orientation." But there is little doubt that he would have appreciated the spirit in which McLuhan asserts that all media "are in the plenary sense linguistic."

MAN IS THE
ONLY ANIMAL
TO
CONTROL TIME
AS A DIMENSION
OF HIS
ENVIRONMENT.

> THROUGH THE VANISHING POINT

American critic and editor Cleanth Brooks told McLuhan that *Through the Vanishing Point* – a joint effort by McLuhan and artist Harley Parker – was McLuhan at his best. *Through the Vanishing Point* brings poems and paintings together to illuminate the world of space created by language. You can see how an artist shows space in a painting, even if you don't know how to paint. With language, it's just the opposite: you know how to talk and write, but you don't (usually) notice how the world of space is expressed in words. So, it should be a little easier to start noticing space in the world of words by coming at it through paintings. (McLuhan's contrast between visual space and acoustic space is a clue to his development of the central idea in his work with Parker.)

McLuhan calls poetry and painting "sister arts" and uses them side by side to do the same job all his other books are intended to do –

train our physical senses

and raise them to a

new
level
of
sensitivity.

So this is all about perspective.

And McLuhan points out that perspective itself is
a mode of perception that involves a single point of view –
or fragmentation, in space and in time, in painting and in poetry.

Here we come back to McLuhan's distinction between
visual space and acoustic space, because

fragmentation

belongs

to

visual

space.

> THE VIEWER BECAME THE VANISHING POINT

All this is a clue for McLuhan to the link between the sensory life of Paleolithic Man and Electronic Man.

We are back to McLuhan's idea of the

retribalization

of

the

Western

world.

Do McLuhan's ideas hold up today? If we survey his ideas, as articulated in his books over nearly four decades, we discover that he consistently issued a challenge, inviting readers to discover the effects of technology in their own lives and to find any technology to which his four interlocking laws of media do not apply or to find any instance where a full and accurate description of the operation of a medium requires an addition to the four laws. Both challenges remain open.

McLuhan said that most people want desperately not to know what is happening to them.

If that state of affairs is changing, and there is some reason to believe it is, then his sign posts to what is happening are as timely as ever.

The following pages are alternative reference materials and author's notes on **Structuralism** and on the writings of **Wyndham Lewis** and **James Joyce**, two of McLuhan's exceptional contemporaries.

McLUHAN AND STRUCTURALISM

McLuhan's thinking in the middle years of the 1970s was dominated by his own unique approach to structuralism. At first, it had little link with the complex and ramified school of thought deriving from the work of the Swiss linguistic genius Ferdinand de Saussure (1857-1913). In the early pages of *Understanding Media*, McLuhan had already outlined structuralism in the broadest terms: the trend of modern thought, in areas as diverse as physics, painting, and poetry, whereby "specialized segments of attention have shifted to total field." It was a trend that supported his notion that the medium is the message, gave the phrase its full meaning, and illustrated effect preceding cause both as a phenomenon of twentieth-century life and in the development of McLuhan's own thought. It was also a trend that could accommodate the probes that McLuhan was still developing.

Shortly before *Understanding Media* had appeared, McLuhan declared that structuralism was fundamental to his method of intellectual inquiry, linking it to "modern depth criticism," meaning Practical Criticism in the manner of I.A. Richards. In McLuhan's own account, more than a decade later, when his overview of the subject had been reconfigured, he continued to acknowledge Richards as the principal source who had nourished his structuralist approach.

Structuralism appealed to McLuhan for its own merits and because it invited the type of interdisciplinary inquiry to which his own natural bent led him. When he said that he had "reached the structuralist stage where content is indifferent," he tied this directly to his media studies. He had learned structuralism as part of his literary apprenticeship at Cambridge, but it had also opened the way to him for media analysis, carrying him permanently beyond the domain of literary scholarship.

The flow of mail in response to *Understanding Media* had brought McLuhan into contact with scholars who detected an affinity between linguistics and McLuhan's approach to media. As a consequence, he began moving toward a structuralism that was much less familiar to him than his legacy from I.A. Richards. It combined the free play between media analysis and linguistics (itself a discipline at the crossroads of anthropology, pyschology, and philosophy) with the prospect of sharpening the original McLuhan probe: the medium is the message.

And so McLuhan delved into a study of Ferdinand de Saussure (Course in General Linguistics) and a new brand of structuralism became part of his working apparatus. He began citing Saussure and his orthodox followers as support of his own idea of media as technological extensions of body and mind. In so saying, McLuhan was on his way to elaborating interlocking laws of media and their associated tetrad structures. Eventually, he would declare that all of mankind's artifacts are structurally linguistic and metaphoric. And just two years before his death, he could call the galaxy of ideas forming structuralism the perfect fulfillment of all his research.

McLUHAN AND WYNDHAM LEWIS

Painter, novelist, and essayist, Wyndham Lewis was the leading figure in the British art movement known as 'Vorticism.' He collaborated with Ezra Pound to found the journal *Blast* in 1914. Though short-lived, the publication did not fail to deliver the effect promised by its title. Its pages filled with 'Blast' and 'Bless,' Lewis's journal proclaimed the demise of British provincialism and heralded the international environment of the new art in dark symbiosis with the internationalism of technology. T.S. Eliot, whose portrait Lewis painted, and I.A. Richards, considered Lewis the supreme living master of English fiction. Like his paintings, Lewis's prose focussed on the artist's role in an age engulfed by technological change.

A satirist, an inquirer, at the top of his form in dialogue, committed to exposing the inadequacies of Naturalism and Symbolism alike, refusing to articulate a canon that could only stifle Vorticism, Lewis had boundless interests that embraced sculpture, architecture, cinematography, and what he called the visual revolution. In *Time and Western Man* he analyzed the world of advertising. McLuhan, assembling material for *The Mechanical Bride*, came looking for Lewis. It was in *Time and Western Man* that Lewis had said "we want a new learned minority as sharp as razors, as fond of discourse as a Greek, familiar enough with the abstract to be able to handle the concrete. In short we want a new race of philosophers, instead of 'hurried men,' speed cranks, simpletons, or robots." Lewis was also looking for McLuhan.

McLUHAN AND JAMES JOYCE

Lectures by F.R. Leavis at Cambridge University first stimulated McLuhan's interest in James Joyce. It was an interest that McLuhan sustained – and that sustained him – till the end of his career. Mentioned only once in McLuhan's doctoral dissertation (1943), Joyce became the most frequently quoted writer in *Understanding Media* (first edition, 1964; critical edition, 2003). Like Chesterton and Lewis, Joyce sensitized McLuhan to the notion of language as technology. Eventually, McLuhan went so far as to give Joyce the credit for having worked out in detail the laws of media, linking Plato's *Cratylus*, with its theory of language as the key to an inclusive consciousness of human culture, to the inseparability of substance and style, of medium and message, in *Finnegans Wake*.

Joyce satisfied McLuhan's appetite for puns. Easily his favorite, because of the link with language, technology, and media effects, was Joyce's allforabit (alphabet). The rich echo teases and teaches that the alphabet as a technology impoverishes the fullness and richness of our sensory experience of the world, throws away all but the visual, fostering the private point of view of literate society.

Time and again, McLuhan quoted Joyce's puns such as 'Who gave you that numb?' as he taught about the numbness, the sensory closure, brought on by print technology and the associated loss of perceptual acuteness and awareness. Through puns, through all his linguistic creativity in *Finnegans Wake*, Joyce demonstrates the art of transcending numbness and making a breakthrough into new kinds of awareness. Joyce's efforts in *Finnegans Wake* to make language physical connected perfectly with the dominant objective of all McLuhan's teaching: to provide a program of training in perception.

Here are some of McLuhan's references to Joyce in *Understanding Media*.

Regarding puns:
The title of his *Finnegans Wake* is a set of multi-leveled puns on the reversal by which Western man enters his tribal, or Finn, cycle once more, following the track of the old Finn but wide awake this time as we re-enter the tribal night. It is like our contemporary consciousness of the Unconscious. (49)

Regarding unity in the age of electricity:
Humpty-Dumpty is an obvious example of integral wholeness. The mere existence of the wall already spelt his fall. James Joyce in *Finnegans Wake* never ceases to interlace these themes, and the title of the work indicates his awareness that "a-stone-aging" as it may be, the electric age is recovering the unity of plastic and iconic space and is putting Humpty-Dumpty back together again. (250)

Regarding the alphabet and print:
Cervantes devoted his *Don Quixote* entirely to this aspect of the printed word and its power to create what James Joyce throughout *Finnegans Wake* designates as **ABCED-minded** which can be taken as **ab-said** or **ab-sent** or alphabetically controlled. (383-84)

Regarding television:
The mode of the TV image has nothing in common with film or photo, except that it offers a nonverbal gestalt or posture of forms. With TV, the viewer is the screen. He is bombarded with light impulses that James Joyce called the "Charge of the Light Brigade" that imbues his "soulskin with sobconscious inklings." (418)

Regarding television:
James Joyce in *Finnegans Wake* headlined TELEVISION KILLS TELEPHONY IN BROTHERS BROIL, introducing a major theme in the battle of the technologically extended senses that has, indeed, been raging through our culture... With the telephone there occurs the extension of ear and voice that is a kind of extrasensory perception. With television came the extension of the sense of touch or of sense interplay that even more intimately involves the entire sensorium. (357)

Regarding photography:

[T]he world of the movie that was prepared by the photograph has become synonymous with illusion and fantasy, turning society into what Joyce called an "all-nights newsery reel," that substitutes a "reel" world for reality. Joyce knew more about the effects of the photograph on our senses, our language, and our thought processes than anybody else. His verdict on the "automatic writing" that is photography was the abnihilization of the etym (etymology). He saw the photo as at least a rival, and perhaps a usurper, of the word, whether written or spoken. But if etym means the heart and core and moist substance of those beings that we grasp in words, then Joyce may well have meant that the photo was a creation from nothing (ab nihil), or even a reduction of creation to a photographic negative. (262)

Regarding telegraph and radio:

Telegraph and radio neutralized nationalism but evoked archaic tribal ghosts of the most vigorous brand. This is exactly the meeting of eye and ear, of explosion and implosion, or as Joyce puts it in the *Wake*, "In that european end meets Ind." The opening of the European ear brought to an end the open society and reintroduced the Indic world of tribal man to West End woman. Joyce puts these matters not so much in cryptic, as in dramatic and mimetic, form. The reader has only to take any of his phrases such as this one, and mime it until it yields the intelligible. Not a long or tedious process, if approached in the spirit of artistic playfulness that guarantees "lots of fun at Finnegan's wake." (404)

IMAGE CREDITS

CITATIONS

p.7, 1 "Now We Know: McLuhan Was Right," *The Reporter,* June 1976, pages 12-13.

p.67, 2 "Printing and Social Change," *Printing Progress* (1959), page 89-112 (reprinted in W Terrence Gordon, ed., McLuhan Unbound, Corte Madera, CA: Gingko Press, 2005)

p.68, 3 "Culture without Literacy," reprinted in W. Terrence Gordon, ed., McLuhan Unbound, Corte Madera, CA: Gingko Press, 2005

p.74, 4 "Notes on the Media as Art Forms," reprinted in W. Terrence Gordon, ed., McLuhan Unbound, Corte Madera, CA: Gingko Press, 2005

p.75, 5 *Explorations 6,* reprinted in W. Terrence Gordon, ed., McLuhan Unbound, Corte Madera, CA: Gingko Press, 2005

p.134, 6 *et cetera/ETC.: A Review of General Semantics* (San Francisco, New York: International Society for General Semantics), Vol. 34 No. 2 June 1977, pages 173-179, reprinted in W. Terrence Gordon, ed., McLuhan Unbound, Corte Madera, CA: Gingko Press, 2005

A SELECTIVE, CHRONOLOGICAL MARSHALL MCLUHAN BIBLIOGRAPHY OF BOOKS DISCUSSED WITHIN THIS BOOK

Marshall McLuhan. *The Mechanical Bride: Folklore of Industrial Man*. New York: Vanguard Press, 1951. Reissued by Gingko Press, 2002.

_____. *The Gutenberg Galaxy: The Making of Typographic Man*. Toronto: University of Toronto Press, 1962.

_____. *Understanding Media: The Extensions of Man*. New York: McGraw-Hill, 1964.

McLuhan, Marshall, Quentin Fiore, and Jerome Agel. *The Medium is the Massage: An Inventory of Effects*. New York: Bantam Books, 1967. Reissued by Gingko Press, 2005.

McLuhan, Marshall, Quentin Fiore, and Jerome Agel. *War and Peace in the Global Village*. New York: Bantam Books, 1968. Reissued by Gingko Press, 2001.

McLuhan, Marshall, and Harley Parker. *Through the Vanishing Point: Space in Poetry and Painting*. New York: Harper & Row, 1968.

McLuhan, Marshall, and Harley Parker. *Counterblast*. New York: Harcourt Brace & World, 1969. Reissued by Gingko Press, 2007.

_____. *Culture is Our Business*. New York: McGraw-Hill, 1970.

McLuhan, Marshall, and Wilfred Watson. *From Cliché to Archetype*. New York: Viking, 1970.

McLuhan, Marshall, and Barrington Nevitt. *Take Today: the Executive As Dropout*. New York: Harcourt Brace Jovanovich, 1972.

McLuhan, Marshall, and Eric McLuhan. *Laws of Media: The New Science*. Toronto: University of Toronto Press, 1988.

_____. *McLuhan Unbound*. Edited by Eric McLuhan and W. Terrence Gordon. Corte Madera, CA: Gingko Press, 2005.

_____. *The Classical Trivium: The Place of Thomas Nashe in the Learning of His Time*. Edited by W. Terrence Gordon. Corte Madera, CA: Gingko Press, 2005.